GW01451397

Japanese Flower Wrapping

Yae-tsutsumi / *Katawana-musubi* knot / Double cherry, maple

Japanese Flower Wrapping

Mitsuko Kawata

Shufunotomo Co., Ltd.

First printing, 1993

Photography by Akira Kumagai
 Tetsuyata Shimazaki
 Jiro Suzuki
 Michio Tanaka
English text supervised by Jane Singer
Book design by Momoyo Nishimura

Published by Shufunotomo Co., Ltd.
2-9, Kanda Surugadai, Chiyoda-ku,
Tokyo, 101 Japan

Printed in Japan
ISBN4-07-975859-6

All styles of Kirara hana tsutsumi *described
in this book have been included in a pending
application for design registration.*

Contents

Foreword

The first written mention of wrapping flowers is found in the *Sendensho*, a book which dates from 1445 and is said to be the oldest book on ikebana in Japan. Thus, it seems that rules for ikebana and for wrapping flowers as gifts were established at about the same time. The *Sendensho* gives instructions for the use of decorative paper strings (*mizuhiki*) as well as paper for wrapping items.

The *Sendensho* was reproduced many times by hand, as it was a popular textbook for generations of instructors. With the advent of printing in the early 1600's, it found an even wider audience.

But even before the *Sendensho* and its written rules appeared, it is thought that flower wrapping existed in Japan. The practice of wrapping objects in paper dates back to ancient times, for elegant handmade paper is known to have existed as early as the eighth century. The samurai warriors who gained power in the Kamakura Period (1192–1333) adopted and further elaborated on the manners and customs of the nobility as practiced at court.

In the Edo Period (1603–1867), when wealth began to be concentrated in the hands of townspeople rather than samurai, the practice of giving flowers as gifts flourished along with urban culture. Another book on flower wrapping, the *Nageire Kadensho*, appeared in the early Edo Period. Its illustrations suggest that there was little difference between flower wrapping of this period and of the earlier *Sendensho*.

By the mid-Edo Period, however, more comprehensive rules governing flower wrapping and wrapping gifts in paper were established. Two well-known schools of etiquette, the Ise and Ogasawara schools, formulated their own rules for wrapping items, including flowers, in paper. The *Teijo Zakki*, written by *Teijo Ise*, includes illustrations of flower-wrapping styles.

Also in the mid-Edo Period, illustrations showing flower wrapping began to become common in many ikebana texts. The *Teishosai* branch of the Enshu School was notable among ikebana schools for having established elaborate wrapping styles for flowers according to the season. These Enshu styles were so popular that they were taught even into the early years of the twentieth century, and many women in Japan today can remember being taught these styles at school.

Ms. Mitsuko Kawata, founder of the ikebana group Kirara-kai, created her styles of *Kirara hana tsutsumi* in order to revive the traditional practice of flower wrapping, based on her study of ancient documents. Now that the practice of giving flowers as gifts is becoming increasingly widespread in Japan, it is only appropriate that this type of modern flower wrapping be further studied and developed with new, creative ideas. As ikebana becomes more and more integrated in our daily lives, I am convinced that Ms. Kawata's efforts to develop and revitalize these ancient ikabana traditions will become increasingly significant. I have great expectations for the future of flower wrapping.

Masanobu Kudo
Ikebana Scholar

Preface

A gift of flowers is an ideal expression of one's feelings for another, as it warms the hearts of both the giver and receiver.

In recent days, gifts of flowers have become increasingly popular among Japanese, and florists shops are filled with beautifully arranged bouquets or flowers exquisitely wrapped in paper. Men carrying bouquets of flowers in their arms as they proceed down the street have become a more common sight.

I often give flowers to others myself; I've begun to think that these floral gifts are a form of ikebana, or flower arrangement. This idea provided the impetus for my involvement in *hana tsutsumi*, or flower wrapping.

In the *Sendensho*, a book on the secrets of ikebana dating back to the Muromachi period (1338–1573), there is the following passage:

"When offering floral materials as a gift: Wrap the lower ends of branches in paper. Also wrap the lower ends of flower stems in paper. Tie the branches in several places and offer the bouquet with the flowers facing downward. You may at times fold the wrapping paper in the shape of a butterfly or flower, and you should offer the bouquet adorned with red *mizuhiki* (stiff paper string)."

Today, most Japanese offer flowers as gifts in the form of Western-style bouquets. However, as mentioned in the Sendensho, making gifts of flowers has long been a Japanese custom as well. Traditionally, there were several rules governing the wrapping of flowers. Flowers were wrapped in folded *washi* (Japanese paper) which was tied with mizuhiki. This practice was known as hana tsutsumi, or flower wrapping, and it was passed on as one of the accomplishments of the ancient samurai warriors.

Some drawings of traditional flower wrapping from samurai times can be seen today. They display an impressively high level of beauty and artistry, but few modern Japanese are aware of this ancient style of flower wrapping, and it is in danger of being forgotten. As I was impressed by our predecessors' aesthetic sense and their heartwarming way of doing things, expressed in the small act of giving flowers, I hoped to recapture that artistic sense in modern Japan by establishing *Kirara hana tsutsumi*, an art based on the traditional practice of flower wrapping and incorporating newly developed elements. My aim has been to have the wrapping serve as a container for flowers, while also being a source of beauty in its own right.

In traditional hana tsutsumi, the style of wrapping depends on the kind of flowers used, but Kirara hana tsutsumi is more flexible and can be applied to various kinds of flowers. To the different forms of wrapping I have given elegant names, such as *Kifune tsutsumi* and *Rikyu tsutsumi*, named for their shapes, uses or poetic allusions. The word *tsutsumi* has many meanings: to cover, hide, encircle, envelop, wrap or enclose. When interpreting this word in a broad sense, it can be applied to all aspects of ikebana.

With Kirara hana tsutsumi, we use special flower containers to arrange the flowers. Articles easily found at home can be used as substitutes, but once you actually use these special containers, you'll find that they are much more suitable for arranging flowers than ordinary goods found in the home. A distinctive characteristic of Kirara hana tsutsumi is that the flowers arranged in this manner and given as gifts can be displayed as received, in the original wrapping. The art thus requires that the gift-giver learn how to arrange the various styles of flower wrapping.

Rather than limiting materials to white or colored paper, I use all kinds of paper in different colors and patterns and of varying quality. Although paper is easily damaged by water, we don't use waterproof paper for flower wrapping, since I feel it's important to retain the distinctive qualities of washi.

Two popular styles of Kirara flower wrapping, *Suehiro tsutsumi* and *Nagisa tsutsumi*, cannot stand on their own. To support them, I devised props known as *hana makura* (literally, flower pillow) and *kanae* (three-legged prop), thus creating a three-dimensional style of displaying these wrapped flowers. The props can be made of the same washi as the wrapping, or you can use stones or something representative of the season as props.

I first tried my hand at hana tsutsumi in 1986, and in 1988 held a solo exhibition of original Kirara hana tsutsumi. Since then, I have been so delighted with the art of wrapping flowers and the functional beauty of tying mizuhiki that I have created and displayed more than 30 styles of Kirara hana tsutsumi through private exhibitions, newspapers, magazines and other media.

The word *kirara* of Kirara hana tsutsumi means "mica." I have named the art of wrapping flowers after the name of my school of ikebana, Kirara-kai (mica group). I chose the word kirara in the hope that my ikebana students and I would always sparkle brightly in the colors of the rainbow.

I hope to continue exploring the potential of ikebana through the practice of Kirara hana tsutsumi, which combines two uniquely Japanese arts: *origata* (the art of wrapping) and ikebana, the art of flower arrangement.

Mitsuko Kawata

Part I
Kirara Hana Tsutsumi
for
the
Seasons
*
Color Combinations
for
Flower Wrapping

Rikyu-tsutsume / Musubikiri-katanagashi knot / Dahlia, greenbrier

Kifune-tsutsumi / Morowana-musubi knot / Carnation, ornithogalum, leather fan

The natural materials used with Kifune tsutsumi can be arranged in one of three different ways, to symbolize three different nautical conditions. Select the appropriate style to match the characteristics of your natural materials or the setting where you will place them.

1 *Defune*: This symbolizes a boat which is hoisting its sail and leaving port. The upright main branch of the arrangement should measure 1.5 times the width of the Kifune-tsutsumi boat. (Opposite page)

2 *Irifune*: This symbolizes a boat which is returning to port, with its sails half-lowered. There should not be much difference in height between the main branch and the other materials. All the branches should be thick and cut fairly low, for a feeling of fullness.

3 *Tomaribune*: This symbolizes a boat sitting at anchor offshore. The Kifune tsutsumi boat is supposed to ride on the waves, with the main branch serving as an anchor. The branch should be cut long and stretch downward. (Shown in p. 36)

Kifune-tsutsumi (*Tsukikusa-gasane*) / *Morowana-musubi* knot / Anemone

The Yae tsutsumi cannot stand on its own; it must be supported by a *hana makura*. Adjust the amount of water in the water container for a stable water level depending on the height of the hana makura.

Yae-tsutsumi / *Katawana-musubi* knot / Cherry blossoms, Fritillary thunbergii

Rikyu-tsutsumi / Musubikiri-katanagashi knot / Cherry blossoms

Since a larger-sized Rikyu tsutsumi can't be supported by a hana makura, we use a special prop I call a *kanae*. The three legs are secured by a braided rope, or *kumihimo*, and the knot is tied so as to achieve a good balance of all three legs. To adjust the height of the legs, simply retie the knot at a higher or lower position.

Akane-tsutsumi / Morowana-musubi knot / Lily-of-the-valley

*Chigusa-tsutsumi / Musubikiri
knot /* Anemone

Temari-tsutsumi /
Fuji-musubi knot /
Tulip

Chigo-tsutsumi / Awabi-musubi knot / Field horsetail

Chigo-tsutsumi / Morowana-musubi knot / Primula

Tango-tsutsumi / Morowana-musubi knot / Japanese iris, Japanese kerria

Japanese celebrate Boys' Day on May 5th. Customarily, irises are arranged on this day, to symbolize boys' healthy growth. For families of newborn baby boys, this day is called *hatsu zekku* (First Boys Day). If invited to a party celebrating hatsu zekku, irises wrapped in Tango-tsutsumi would be a highly appropriate gift.

Miyabi-tsutsumi / Musubikiri-katanagashi knot / Iris

St. Valentine's Day on February 14 is celebrated in Japan as an opportunity for girls or young women to confess their affection to young men. The women often present men with chocolate and irises. According to a Greek myth, the iris is said to express a "message of love." For such a valentine gift, use mizuhiki in the same color as the iris.

Fuki-tsutsumi / Morowana-aioi-musubi knot / Rhododendron

Fuki-tsutsumi / Morowana-aioi-musubi knot / Tree peony

Chigo-tsutsumi / *Awabi-musubi* knot / Lily of the valley

Shikibu-tsutsumi / *Musubikiri* knot / Wisteria,
maple, judas-tree

Rikyu-tsutsumi / Musubikiri-katanagashi knot / Rose, loquat

Tamaki-tsutsumi / Musubikiri knot / Rose, varigated plantain lily

*Kocho-tsutsumi /
Musubikiri-
chirikakenagashi*
knot / Rose,
Allium schubertii

Chigusa-tsutsumi / Musubikiri knot / Cosmos

Kocho-tsutsumi / Musubikiri-chirikakenagashi knot / Daisy

Kasane no irome (layers of color): The pale green outer sheet of paper and the light green inner sheet combine for a soft color tone. This layering of color provides the effect of a plant before it matures. The texture and color of the hand-made washi combine beautifully with the yellow daisies and the pearl-colored mizuhiki.

Kaze-tsutsumi (*Moegi no Nioi*) / *Fuji-musubi* knot / Glory lily

30

Kaze-tsutsumi / *Fuji-musubi* knot / Pansy

Nagisa-tsutsumi / Morowana-musubi knot / Delphinium, two kinds of allium, statice

Shinoda-tsutsumi / Delphinium, superb pink

Yae-tsutsumi / Katawana-musubi knot / Baby's breath, rose

Nagisa-tsutsumi / Morowana-musubi knot / Cherry leaves, smoketree

Nagisa-tsutsumi / Morowana-musubi knot / Casablanca lily

Kifune-tsutsumi / Musubikiri knot / Sasa bamboo

Rikyu-tsutsumi / Musubikiri-katanagashi
knot / Lizard's tail, morning glory

Unlike flowers in a ceramic vase, Kirara hana tsutsumi can be placed in a variety of positions – upright, hanging, reclining; it's up to one's imagination to discover where to place it.

As this Rikyu-tsutsumi arrangement emphasizes the beauty of the mizuhiki, I used a *suihatsu* (Japanese hook) and suspended it from the wall for an unusual effect. When hanging Kifune-tsutsumi arrangements in the air, the Tomaribune style, in which a low-hanging branch expresses the effect of a boat at anchor, is most appropriate. Arrange the flowers simply and complete the color effect with thin braided string.

Sayo-tsutsumi / *Musubikiri* knot / Foxtail millet

Yae-tsutsumi / Musubikiri-katanagashi knot / Greenbrier, Chinese bellflower, speedwell

Shikibu-tsutsumi / *Musubikiri* knot / Lady's slipper, white alder

Miyabi-tsutsumi / Awabi-musubi knot / Rugosa rose

Aya-tsutsumi / Ladies' tresses (*Spiranthes sinensis*)

Chigusa-tsutsumi / Musubikiri knot / Cosmos

Kocho-tsutsumi / Musubikiri-chirikakenagashi knot / Sunflower

Tamaki-tsutsumi /
Umenohana-musubi
knot / St. John's
wort, lily, superb
pink

Akebono-tsutsumi / *Morowana-musubi* knot / Pineapple

Yae-tsutsumi / Katawana-musubi knot / Anthurium, banana leaf

Kocho-tsutsumi / Musubikiri-chirikakenagashi knot / Amacrinum, beloperone

(Opposite page: Top)
Rikyu-tsutsumi / Musubikiri-katanagashi knot / Dimorphotheca, hypericum
(Bottom)
Nagisa-tsutsumi / Morowana-musubi knot / Mountain-ash, patrinia, great burnet, golden-banded lily, superb pink, gentian

Ikada-tsutsumi /
Chestnut, Chinese
bellflower

Suehiro-tsutsumi / Awabi-musubi knot / Japanese spirea, common yellow loosestrife

Shikibu-tsutsumi / *Musubikiri* knot / Scabiosa

Rikyu-tsutsumi / *Musubikiri-katanagashi* knot / Calla lily

Choyo-tsutsumi / Musubikiri
knot / Chrysanthemum
(dressed cotton)

Chigusa-tsutsumi /
Musubikiri knot /
Camellia,
spindle-tree

54

Tamaki-tsutsumi / Umenohana-musubi knot / Rahiolepis, narcissus

On September 9th we celebrate the Chrysanthemum Festival. A practice once carried out on this day, called *kisewata*, involved placing a length of cotton on an outdoor display of chrysanthemum. The dew-covered cotton would be used the next morning for washing one's body. In this Choyo-tsutsumi arrangement, the use of nine yellow chrysanthemums evokes this ancient custom.　(Opposite page: top)

Tamaki-tsutsumi / Umenohana-musubi / Japanese apricot, camellia

Mai-tsutsumi / Kikka-musubi knot / Superb pink, marica (*Neomarica northiana*)

Combining Colors in Traditional Style

One of the most beautiful examples of combining colors dates from the Heian period (794–1192). Court ladies at that time wore a style of ceremonial kimono called *junihitoe*, or twelve-layered costume. The beautiful color scheme used in layering the kimono was called Kasane-no-irome. While this phrase originally referred to the combinations of colors visible at the front and back collar of the costume, it later came to be used for any color scheme produced by layering kimono.

The Kasane-no-irome scheme seeks to duplicate the colors of the natural environment, with different schemes expressing the changing seasons or changing colors around us. Each scheme was given a beautiful name, reflecting the sensitivity of the nobility during the Heian period, whose lifestyles reflected an ideal of living in harmony with the natural environment.

Today, such elaborate color schemes can only be seen in paintings or photographs. I wanted to bring some of this culture of colors into our lives, by incorporating these schemes in the washi used for hana tsutsumi. Although our modern dying technology differs from that used in the Heian era, and the colors of cloth and paper are not the same, I feel we can learn much from studying the ways these ancient Japanese expressed the seasons using color.

Color combinations for the four seasons
The following are combinations to be used for layering washi in hana tsutsumi, according to the season. "Face" refers to the outer sheet of washi and "reverse" to the undersheet. (with the face color on the right).

Spring
Two-color combinations

Umegasane
Japanese apricot.
Face: *kokikurenai* (bright red)
Reverse: *kobai* (bright purplish-pink)

Wakakusa
Fresh grass of spring.
Face: *usuao* (light yellowish-green)
Reverse: *kokiao* (deep green)

Sakura
Cherry blossoms in full bloom.
Face: *shiro* (white)
Reverse: *akaki-hana* (bright yellowish-red)

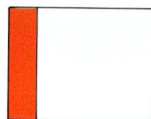

Sumire
Violet.
Face: *murasaki* (deep purple)
Reverse: *usu-murasaki* (light purple)

Six-color combinations
Moegi-no-nioi
The harmony of different shades of moegi-iro (yellowish-green) imparts a sense of the fresh grasses and plants of spring. The red color provides balance.

The colors of the upper layers of washi are light, deepening in the lower layers and ending with a red layer.

Usumoegi yoriawaku (pale green) – *usumoegi* (light green) – *moegi* (pea green) – *moegi* (pea green) – *kokimoegi* (light yellow-green) – *kurenai* (red)

Summer
Two-color combinations

Kaede
Maple tree in early summer.
Face: *ao* (deep blue-green)
Reverse: *ao* (deep blue-green)

Unohana
White Japanese sunflowers.
Face: *shiro* (white)
Reverse: *ao* (deep blue-green)

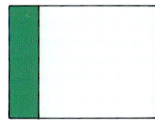

Yuri
Small red star lily.
Face: *aka* (bright yellowish-red)
Reverse: *kuchiba* (dull reddish-
 yellow, like dead leaves)

Sohbi
Rose, the queen of the flowers.
Face: *kurenai* (bright red)
Reverse: *murasaki* (violet)

Six-color combinations
Shobu
Japanese iris. The colors express the fresh hues of
early summer blossoms.

Ao (deep blue-green) – *usuao* (light green) – *shiro*
(white) – *kobai* (deep purplish-pink) – *usukobai* (light
pink) – *shiro* (white)

Autumn
Two-color combinations

Hagi
Bush clover, plain but appealing colors.
Face: *murasaki* (deep purple)
Reverse: *shiro* (white)

Kuchiba
Yellowish-brown, proves that
beauty can be found even in the
colors of dead or decayed leaves.
Face: *kokikurenai* (bright red)
Reverse: *kokiki* (bright yellow)

Shion
Aster, swaying in the autumn wind.
Face: *murasaki* (violet)
Reverse: *suoh* (strong purplish-red)

Momiji
Red maple leaves, a sign of autumn,
with brown decaying leaves.
Face: *aka-iro* (strong yellowish-red)
Reverse: *kokiaka-iro* (reddish-brown)

Kugatsugiku
September chrysanthemum, a
typical autumn flower. White and
yellow mums are the most beautiful.
Face: *shiro* (white)
Reverse: *ki* (golden yellow)

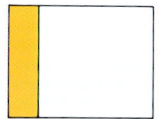

Six-color cmbinations
Kurenai-momiji
Red maple leaves. The top and bottommost layers
are the color of maple leaves in autumn, while the
inside colors are their shadow colors.

Kurenai (red) – *usukuchiba* (light yellowish-brown) –
ki (golden yellow) – *kokiao* (deep green) – *usuao*
(light green) – *kurenai* (red)

Winter
Two-color combinations

Kareiro
Desolate winter fields.
Face: *usuko* (beige)
Reverse: *ao* (deep green)

Koori-gasane
Layer of ice, augmented by the color
of the earth.
Face: *torinokoiro* (light beige)
Reverse: *shiro* (white)

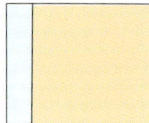

Yukinoshita
Strawberry geraniums. Spring
blossoms are waiting to emerge from
under the snow.
Face: *shiro* (white)
Reverse: *kobai* (bright purplish-pink)

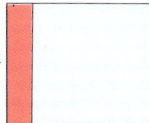

Tsubaki
Several colors of camellia.
Face: *suoh* (strong purplish-red)
Reverse: *aka* (strong yellowish-red)

Six-color combinations
Yukinoshita
Spring flowers wait to emerge from beneath drifts
of snow.

Shiro (white) – *shiro* (white) – *kobai* (bright purplish-
pink) – *usukobai* (light purplish-pink) – *usukobai* (light
pink) – *ao* (deep blue-green)

Rikyu-tsutsumi / Musubikiri-katanagashi / Baby's breath, misty blue

Tamaki-tsutsumi / *Umenohana-musubi* knot / Amaryllis, lilac, lace flower

(On pages 62–63)
Nagisa-tsutsumi (*Kurenai-momiji*) /
Morowana-musubi knot / Moss-covered
pine, ilex serrata

*Chigusa-tsutsumi /
Musubikiri* knot / Paris
daisy

*Temari-tsutsumi / Fuji-
musubi* knot / Cam-
panula, lace flower,
allium, ornithogalum

Chigusa-tsutsumi / *Oi-no-nami* knot / Gerbera, baby's breath, bouvardia

Miyabi-tsutsumi / *Awabi-musubi* knot / French marigold, prairie gentian, thistle

Tamaki-tsutsumi / Umenohana-musubi knot / Banana leaf, agapanthus

Kifune-tsutsumi / Morowana-musubi knot / Blue star

*Suehiro-tsutsumi /
Morowana-musubi* knot /
Chinese monkshood,
prairie gentian

Suehiro-tsutsumi / *Awabi-musubi* knot / Calla lily, fennel

Tamaki-tsutsumi / *Uroko-musubi* knot / Sandersonia, solidaster, alstroemeria

Ikada-tsutsumi / Gladiolus

Ikada-tsutsumi / Common zinnia

Izutsu-tsutsumi / Dahlia

Kocho-tsutsumi / *Musubi-kiri-chirikakenagashi* knot /
Anthurium, fern

Part II

The Pleasure
of
Kirara Hana Tsutsumi

*

Instructions
for
Flower Wrapping

*

Tying
of
Mizuhiki and Kumihimo

*

Washi
(Japanese Paper)

Temari-tsutsumi / Fujimusubi knot /
Anemone

Kirara hana tsutsumi involves not just the pleasure derived from wrapping arranged flowers but also the pleasure of arranging the flowers to be wrapped.

Hanging several Kaze-tsutsumi arrangements on the wall can look very attractive. Or a group of these arrangements can be hung together to serve as a room divider.

When wrapping flowers in washi, one tends to think that they should be of fairly modest size. Actually, floral materials of any size can be used for Kirara hana tsutsumi, and they can be arranged in an endless variety of styles, depending on one's creative ideas.

Kaze-tsutsumi / Fuji-musubi knot / Clematis

Hisho-tsutsumi / Kikka-musubi knot /
Flowering peach, Stagazer lily,
American dogwood

*Kocho-tsutsumi / Musubikiri-chirikake-
nagashi* knot / Lilac, geranium,
amarcrinum

Chigusa-tsutsumi / *Musubikiri* knot / Calla lily, Solomon's seal

Aya-tsutsumi / Umenohana-musubi
knot / Ochna serrulata

Rikyu-tsutsumi / Musubikiri-katanagashi
knot / Weeping forsythia, maple,
chrysanthemum alstroemeria,
columbine

The Styles of Kirara Hana Tsutsumi

Akane tsutsumi

The reverse fold of paper in the center front of this style of wrapping looks like a blaze of sunshine, so I named this style Akane, which means a deep, vibrant red color. Mizuhiki, or stiff paper string, is tied in an even double-looped bow to achieve an overall balance.

Chigo tsutsumi/Nukata

In the Chigo (child) style of wrapping, the paper is folded in petite folds. This type of wrapping is usually used inside a frame, so we fold the lower front to inside, so the wrapping doesn't come loose.

Chigusa tsutsumi

Since this style is used for wrapping various types of flowering plants, I named it Chigusa (one thousand grasses). The distinctive feature of this style is the overall balance presented by the triangular shape in the middle of the wrapping, set off by horizontal lines on both sides.

Izutsu tustsumi

This style is in the form of a four-cornered base. Since its shape is trapezoidal rather than a simple square, it creates a sense of stability for the arrangement. Because of its shape I called it Izutsu, which refers to a square fence surrounding a well.

Ikada tsutsumi

We achieve this style simply by folding and overlapping both ends of the paper. As it reminds me of a simple raft made from a carved log, I called it the Ikada, or raft style. We can add variety to this design, which is tied with mizuhiki, by applying different types of *chirikake*, or curling.

Kaze tsutsumi

I thought up this wrapping style when I first held the Japanese washi called Tengujo, which is as thin as the wings of a cicada, in my hands. Since this form looks as though it was being puffed out by gusts of wind inside it, I named it Kaze (wind). To fill out the interior space we place a small water container inside the form.

Kifune tsutsumi

I named this style Kifune, or boat, since that's what it resembles, with both ends turning upwards like a boat's prow. Each fold of the paper is pulled out to emphasize it and add dimensionality.

Rikyu tsutsumi

The key to achieving this style is in the way of tying the mizuhiki. This style of tying, Musubikiri katanagashi, in which one end is left quite long, is an original technique. The wrapping style itself is called Rikyu because the sweeping outline of the mizuhiki reminded me of the gray-green rain (*rikyu nezu*) mentioned in a famous poem by Hakushu Kitahara, "Rain on Jogashima Island."

Sayo tsutsumi

Tie mizuhiki firmly so that no gaps appear in the center front. For this type of hana tsutsumi, a large volume of modest flowers will help achieve an overall balance. Use high-quality paper for this stable, basic style.

Shinoda tsutsumi

A distinctive characteristic of this style are the beautiful oblique lines converging at a point in the lower front. The style reminds me of the angular face of a fox, so I named it after the name of a white fox in a famous story, "Shinoda no mori."

Suehiro tsutsumi

The reverse side of the paper is turned up like a Japanese fan in this style, which I call Suehiro or fan. In Japan, a fan is a symbol of good luck because an unfolded fan spreads out expansively, denoting increasing prosperity. The mizuhiki here is tied in what is known as the abalone style.

Tamaki tsutsumi

In this very simple style, the reverse side of the paper is turned up in the center front. I named it Tamaki, or circle, because it is usually used to wrap a cylindrical water container. Different ways of tying the braided string can give us a sense of the seasons.

Yae tsutsumi

The Yae or multilayered style involves folding the washi in multiple folds. Its distinctive feature is that the paper used in the lower front overlaps with the paper used in the upper front. Muzuhiki tied in a simple bow (*katawana-musubi*) helps create an overall harmony.

Tango tsutsumi

I created this wrapping style in honor of the annual Boys' Day (Tango), celebrated on the fifth of May. Japanese custom dictates that we use irises when arranging flowers for this occasion, so this prone style is suitable for flowers like the iris which have a flat root.

Miyabi tsutsumi

This wrapping style connotes the elaborate patterns found in the washi used for a Japanese fan. Due to its elegant image, I named it Miyabi, or court-style, wrapping. The discrepancy in height between the two folded sections in front, which makes them look as if they've been cut apart, adds a distinctive flair.

Fuki tsutsumi

I created this style to wrap peonies and named it Fuki (riches), because peonies symbolize wealth and abundance. The mizuhiki is tied in a style known as Morowana-aioi-musubi.

Temari tsutsumi

This style is used to wrap spherical water containers. Its rounded shape has earned it the name Temari, or handball. You can hang this arrangement or place it on a prop called a *madoka*, made of mizuhiki knitted together in a circular shape.

Kocho tsutsumi

The three-dimensional character of this style enables you to use it to arrange flowers as you would using an ordinary vase. The curled tip of the tied mizuhiki reminded me of the antenna of a butterfly (*kocho*).

Nagisa tsutsumi

This wrapping style features the full length of the washi. I named it Nagisa (beach), because the many-layered folds, all facing the same direction, resemble waves lapping a beach. This is an appropriate style for use with a large plant, such as a flowering tree.

Shikibu tsutsumi

Since this style reveals the water container inside the wrapping, we use an attractive container, such as one made of green bamboo or black lacquerware. With the beautiful lines of the front folds extending to either side, this is one of the most elegant wrapping styles.

Aya tsutsumi

I created this style to arrange *nejibana*, a type of orchid. Although we don't use washi, this is also considered a type of flower wrapping, which uses seven beautiful colors of silk thread. I named the style Aya, meaning design or pattern.

Choyo tsutsumi

This style was developed in honor of the Choyo (chrysanthemum) Festival, which occurs on the ninth day of the ninth month. It symbolizes a Japanese custom known as *kisewata*, in which you place a length of cotton overnight over some chrysanthemum flowers and the next morning the cotton is soaked with dew, with which you purify your body.

Mai tsutsumi

Several layers of washi are beautifully folded in this style of flower wrapping. With its display of several layers of differently colored washi, it reminds me of the beautiful contrast of color and texture presented by the 12-layer *junihitoe* kimono worn by noble women in the Heian period (794–1185). I named it Mai, after the image of a noble dancer, or *maihime*.

Hisho tsutsumi

This very elegant style, our largest in size, pairs flowers right and left. I named it Hisho (flying), because with its shape it resembles something in flight, with wings outstretched.

Flower Wrapping, Step by Step

Akane tsutsumi

1. Prepare two sheets of 30 cm × 30 cm (12″ × 12″) paper back to back, a cylindrical water container and mizuhiki.

2. Set the water container on the paper, with the under sheet facing up, and wrap the container from the left side.

3. Place the right side over the left (2) and fold back the end 1.5 cm (⁹⁄₁₆″) in width at top and bottom.

4. Fold back again as in (3).

5. Fold bottom section to the rear. Tie mizuhiki in a bow to complete.

Chigo tsutsumi

7. Fold down the right side again so top sheet shows; fold should be very narrow, especially at base.

1. Prepare two sheets of 18 cm × 18 cm (7⅛″ × 7⅛″) paper back to back, a thin cylindrical water container and mizuhiki.

3. Fold back the right side from one-fourth from the top right.

5. Fold the right side from one-fourth the distance from the crease made in (3), keeping the right bottom visible.

8. Fold right side (7) up again, leaving one-third of the remaining width showing.

2. Place the water container atop the double sheets, with the under sheet facing up, and fold from one-third from the top of the left side all the way to the right bottom corner.

4. Open the fold (3) and fold down the triangle at upper right, overlapping the left side.

6. Turn up (5) to the right from about one-third the distance from the crease.

9. Fold right side over left again along crease made in (3) and turn bottom tip to the back. Tie mizuhiki to complete.

89

Chigusa tsutsumi

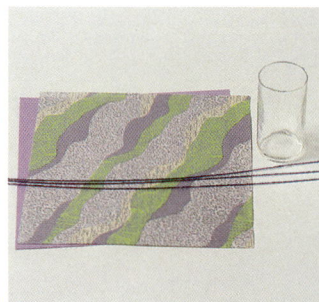

1. Prepare two sheets of 40 cm × 40 cm (16″ × 16″) paper back to back, a glass and mizuhiki.

4. Unfold the paper and fold in half lengthwise from left to right, with the upper sheet slightly higher than the lower sheet.

2. With the underside facing up, fold the two sheets in half diagonally from left to right.

5. Fold up the paper inside by about one-third to the right from the crease made in (4) to form a triangle.

3. Fold the paper in half again from top to bottom, but just crease gently.

6. Open up the paper, holding the triangle made in (5).

7. Fold another triangle from the line made in (2) in the same way as the inside fold.

10. Turn the paper upside down, and repeat from (3) to (8) on the other half.

13. Determine where to tie the mizuhiki.

16. Reset the water container in the paper, flattening the paper at the bottom.

8. Place the right hand corners of the upper and lower sheets together.

11. Fold the paper to achieve the final shape.

14. Remove the water container and make a hole large enough to insert the mizuhiki.

17. Tie the mizuhiki.

9. Flatten the fold.

12. Place the water container inside in the center.

15. Thread the mizuhiki through the hole.

18. Adjust the final shape.

Izutsu tsutsumi

1. Prepare one sheet of 26 cm × 26 cm (10¼″ × 10¼″) paper and a squat square water container.

1. Prepare one sheet of 26 cm × 26 cm (10¼″ × 10¼″) paper and a squat square water container.

2. Fold the paper, with reverse side showing, diagonally from top to bottom.

3. Fold again from left to right.

4. Grab the upper of two folded triangles and refold it so that the upper and lower creases meet at the bottom.

7. Place the right-hand section atop left-hand section.

10. Turn up triangle at the base.

13. Repeat (10) and (11) on other side.

5. Turn the paper over and repeat (4) with the other folded triangle.

8. Fold left side of top sheet to meet crease in the center, then fold the right side.

11. Tuck in protruding section of paper.

14. Turn upside down so top point is at bottom axis.

6. Fold up the top part of the folded paper to make a new triangle, turn over and repeat with bottom part.

9. Turn over, place right-hand section atop left and fold paper in the same way as (8).

12. Fold paper in half with right over left.

15. Open up and flatten to form box-shape, tucking protruding sections inside.

Ikada tsutsumi

5. Lift the tip of the triangle folded in (4) and the lower end for three-dimensional effect.

8. Make a hole in the center of the tucked paper.

1. Prepare one sheet of 51 cm × 39 cm (20½″ × 15⅜″) paper, a small glass and two strands of mizuhiki.

3. Then fold down the top one-fourth to meet the bottom.

6. Tuck in 2–3 cm (¾″ – 1¼″) of paper behind it.

9. Fold a strand of mizuhiki in two and put the folded tip through the hole.

2. With the reverse side up, fold up the bottom one-fourth of the length of the paper.

4. Turn the paper so its long sides point upward and fold the lower right to make a 5 cm triangle.

7. Repeat (6), making five tucks as shown in the photograph.

10. Tie the mizuhiki firmly to secure the paper.

Kaze tsutsumi

3. Gather up the righthand side of the paper around the water container, leaving the lower right corner protruding as in (2).

6. Arrange tucks uniformly around the opening of the container.

1. Prepare one sheet of very thin, 40 cm × 40 cm (16″ × 16″) paper, a small water container and braided rope.

4. Make even tucks in the left-hand side as you gather up the lower left corner.

7. Adjust the wrapping for evenness.

11. With a needle or similar instrument, curl the tips of the mizuhiki. Do the same thing to the other side of the paper to complete.

2. Stand water container upright in center of the paper and gather up the lefthand side of the paper, leaving the upper left corner protruding.

5. Gather up the righthand side more, but still let the lower right corner protrude slightly.

8. Tie the braided rope in Fujimusubi style and tighten firmly.

Kifune tsutsumi

5. Firmly fold lower section of paper toward you in half lengthwise facing the center fold.

8. Lower, folded section of paper shown in photograph will be model for further pleats.

1. Prepare two sheets of 31 cm × 35 cm (12⅜″ × 14″) paper back to back, a piece of braided string 1.5 times the width of the paper and a special water container.

3. Fold lightly lengthwise in three accordian-style pleats of equal width.

6. Hold the section folded in (5) lightly with your left hand and take up remaining sections with your right hand.

9. Holding folded width in (8) in both hands, turn the paper over to the reverse side and fold back top in same width as (8).

2. With the top sheet facing up, fold paper in half lengthwise so that fold is at top.

4. Spread out bottom fold to display under sheet.

7. Spread paper out.

10. Holding folded section with both hands, turn over paper and fold back as in (9).

11. Repeat (9) and (10) on alternating sides of paper to produce accordian-pleated paper. First and last folds of paper should be with same side facing up.

14. Tie string the same way at other end.

17. The inside of the boat near the knots should remain puffy and unstraightened.

20. Gently unfold as in (19) one-third of the distance from the other knot.

12. With under sheet facing up, put braided string around the pleated paper one-sixth of its length from the end.

15. Unfold the pleats in the center, leaving the pleats on either side of the center still folded.

18. Gently unfold the inside pleats on each side of the center.

21. Set the water container inside.

13. Tie string in Moronawa-musubi knot.

16. The section unfolded in (15) will be the bottom of the boat.

19. Hold the outer edge of the paper and the outermost pleat and gently unfold one-third of the distance from one of the knots.

22. Carefully flatten and straighten out the shape of the boat from outside.

Rikyu tsutsumi

1. Prepare two sheets of 26 cm × 34 cm (10¼″ × 13⅜″) paper back to back, a narrow cylindrical water container and five strands of mizuhiki.

2. With the under sheet of paper facing upwards, place the water container diagonally on the paper and fold back a lower-left triangular section of paper measuring one-third of the length and three-fifths of the width of the paper.

3. Fold down a righthand triangular section of paper from slightly left of the halfway point lengthwise to the right bottom tip.

4. Fold back so under sheet faces upwards 2 cm in from pleat in (3).

5. Fold back two-thirds of (4) so top sheet faces upward.

6. Fold back so under sheet faces upwards 2 cm in from pleat in (5).

7. Wrap the water container and smooth out the shape.

8. Fold back the bottom section and tie mizuhiki in Musubikiri-katanagashi knot.

Sayo tsutsumi

5. With a needle, pierce a hole in the paper 1 cm in from pleat on both sides of paper.

1. Prepare one sheet of 27 cm × 27 cm (11″ × 11″) paper, a small glass and five strands of mizuhiki.

3. Set the glass upright and wrap from the left, with bottom left tip folded back.

6. Thread mizuhiki through the holes.

2. With the front of the paper facing up, fold diagonally to form a triangle pointing up.

4. Wrap right side of paper around glass and fold back right tip as in (3).

7. Tie mizuhiki firmly in Musubikiri knot so center pleats meet.

Shinoda tsutsumi

5. Hold the top point and flatten that section into a new triangle.

8. Fold up the lower part of the paper as in (7) so it meets the upper part.

1. Prepare one sheet of 35 cm × 56 cm (14″ × 22⅜″) paper and a long, thin water container.

3. Fold the lower left up diagonally to form a triangle.

6. Hold the bottom point and flatten similarly to form a triangle the same size as in (5).

9. Pull the two protruding triangles out.

2. With the reverse side up, fold the paper diagonally from the upper left to the bottom to form a triangle, then unfold.

4. Fold again in triangular shape so center crease points to upper left corner, unfold and fold again in triangular shape so center crease points to midpoint at bottom. You should have formed three triangles, with two points sticking up.

7. Fold down the upper part of the paper.

10. Fold the square part of the paper back under the triangles.

Suehiro tsutsumi

3. Fold back along the right side a thin length measuring one-third of the paper's width at the top and 3 cm (1³⁄₁₆″) at the bottom.

6. Fold the right side back again by the same width as in (5).

11. Spread out the square part of the paper and fold in along edge to strengthen it.

1. Prepare two sheets of 30 cm × 30 cm (12″ × 12″) paper back to back, a large cylindrical water container and five strands of mizuhiki.

4. Wrap the water container completely so that the left and right sides of the paper meet in front, with the righthand side overlapping the left.

7. Arrange the right and left sides so they're even.

12. Refold it and place the paper upright, with the square part serving as the base.

2. Set the water container diagonally on the paper, with the under sheet facing up and begin wrapping from the left, with a section of the lower left corner measuring one-fourth of the length on one side folded back.

5. Fold the right side again 1 cm (½″) to 2 cm (¹³⁄₁₆″) in from the former crease.

8. Turn back the bottom tip of the paper and tie mizuhiki in an Awabi-musubi knot.

Tamaki tsutsumi

5. Press down to crease firmly.

1. Prepare two sheets of 15 cm × 38 cm (6″ × 15″) paper back to back, a length of braided rope 2.5 times the width of the paper and a fat cylindrical water container.

3. Fold back the right edge of the paper by one-fourth the diameter of the water container.

6. A view of the paper and container from its base.

2. With the under sheet facing up, begin wrapping the container from the left side.

4. Fold the right edge back again by the same width as (3).

7. Tie the braided rope firmly in an Umeka-musubi knot in the center and secure in the back.

Mizuhiki and Kumihimo

Mizuhiki is made of *koyori* (tightly twisted, long, narrow sheets of washi) to which *mizunori* (liquid glue) is applied. Originally, mizuhiki were dyed in white, then in red and white and presented as a gift to important people or to superiors. Later, gold and silver mizuhiki began to be produced for use as gifts for those of high standing. Since modern Japan is basically an egalitarian society, both types of mizuhiki are now used quite commonly.

Varieties and dimensions of mizuhiki

Some mizuhiki combine two colors, such as red and white or gold and silver, and new types of mizuhiki – pearl, *sunago*, *kinumaki*, *akebono* and others – come in a variety of colors. Each offers unique features. In this book, delicately shaded mizuhiki are used to match the color of the hana tsutsumi washi or the flowers. Pure gold and pure silver are sometimes used in making gold and silver mizuhiki.

Five lengths of mizuhiki in two colors make one set. The standard sizes are 60.5 cm (24¼") and 77 cm (30¹³⁄₁₆") in length, which are expressed as No. 20 and No. 25, respectively.

Mizuhiki etiquette

Muzuhiki usually come in an odd-numbered set. According to the Chinese science of divination and Japanese custom, an odd number is regarded as positive and an even number as negative.

It is customary to place the darker colored strands on the right in the case of two-colored mizuhiki. For example, with mizuhiki of red and white, the red strands should be on the right; with a combination of gold and silver, the gold mizuhiki should be on the right.

Mizuhiki use

Adjust the thickness of the mizuhiki according to the number of strands used. You can create different shades by combining several shades of the same color or can create a striped pattern by combining different colors. Mizuhiki can produce a straight line, or you can form a curved line by curling it. Flexible use of the mizuhiki in bending it, however, takes repeated practice.

Kumihimo (braided rope)

Himo (rope) refers to a thick rope used to bundle, fasten or tie things. There are seven types of himo, according to the methods used to make them: *tachihimo*, *kukehimo*, *orihimo*, *tsukanehimo*, *kumihimo*, *yorihimo* and *amihimo*. Kumihimo are used in this book.

Musubikiri

Morowana-musubi

3. Hold the white strands in your right hand and loop the red strands beneath them.

3. Draw your thumb out of the red loop and hold the white strands facing you.

1. Cross the right-hand red strands of mizuhiki over the left-hand white strands.

4. Press the knot down with your left hand and pull ends to tighten.

1. Cross the right-hand red strands of mizuhiki over the left-hand white strands and repeat steps (1) through (4) for Musubikiri knot.

4. Pass the white strands under the loop of the index finger, make loops and secure firmly.

2. Pass the red strands beneath the white and pull both to tighten.

5. Tie mizuhiki firmly. The knot should be white.

2. Holding the white strands in your right hand, loop the red strands around the thumb of your right hand and grab the base of the loop with your left hand.

Awabi-musubi

3. Form a large loop with the red strands and set end atop red strands to right side.

6. Pass it over the red loop to left.

1. Cross the red, right-hand mizuhiki over the white, left-hand strands.

4. Pass the tip of the white strands over the tip of the red and beneath the red strands to right.

7. Slowly tighten the knot, keeping an even shape.

2. Hold the point at which the strands cross in your left hand and the tip of the red strands in your right hand.

5. Pass it over the red loop and under the white strands to left.

Musubikiri-katanagashi Mitsuba-musubi

1. Cross the red, right-hand mizuhiki over the white left-hand strands, with the red strands longer.

2. Repeat the same procedure as in steps (1) to (4) of Musubikiri. Hold the white strands in your right hand and loop the red strands beneath them.

3. Tighten the knot and arrange the long red strands to the right so they flow naturally.

1. With three strands of mizuhiki, cross the right-hand strands over the left-hand strands, with the left strands longer.

2. Pass the upper strands under the lower and pull both ends to secure.

3. Loop the longer mizuhiki around your left index finger and hold the base of the loop in your right hand.

4. Loop the shorter mizuhiki around the longer loop and pass it under the base of (3).

5. Separate each loop of mizuhiki to create a three-leaf shape to the left.

Uroko-musubi

3. Holding the two ends in your left hand, pass them over your left index finger and point them downwards.

6. Tighten the knot and even the loops to arrange the shape.

1. Cross the left strand of braided rope over the right strand, then pass it under the right strand.

4. Fold the left loop to the upper right.

2. Make a loop with the left strand and pass the end under the rope at left, then do the same with the right strand.

5. Fold the right loop over (4) and pass through loop held by left index finger.

Sakuranohana-musubi

3. Fold the right loop to the left, securing it between your thumb and index finger.

6. Holding onto the two loops with both hands, lift your index finger from the knot and straighten out all the loops. The ends should face upwards.

1. Form two large loops with one strand of mizuhiki and hold the base of the loops in your left hand.

4. Place the left loop over (3).

7. Wind the two ends around your index finger, facing downwards.

2. Wrap the two ends around your left thumb and to the rear between the two loops.

5. Pass the left loop under the ends held by your thumb.

8. Fold the left loop to the right in front of the two ends.

Fuji-musubi

9. Place the right loop in front of the left and through the loop held by the thumb.

12. Form the loops into the shapes of cherry blossom petals.

3. Holding the right-hand end pointing to the left, wind the left-hand end around it twice.

10. Remove the thumb and gently pull out the loops to even them.

13. Indent each petal to resemble a cherry blossom petal.

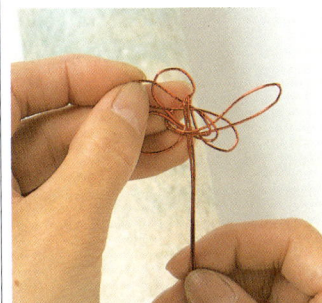

1. Cross the right strand of braided rope over the left.

4. Straighten the braided rope.

11. Pull the strand ends down gently.

2. Wind the right strand twice around the left and pull both ends to tighten.

5. Tighten firmly to secure.

Umenohana-musubi

(Same as for steps 1–10, Sakurano-hana-musubi, page 108)

3. Fold the right loop to the left, securing it between your thumb and index finger.

6. Holding onto the two loops with both hands, lift your index finger from the knot and straighten out all the loops. The ends should face upwards.

9. Place the right loop in front of the left and through the loop held by the thumb.

1. Form two large loops with a length of braided string and hold the base of the loops in your left hand.

4. Place the left loop over (3).

7. Wind the two ends around your index finger, facing downwards.

10. Remove the thumb and gently pull out the loops to even them.

2. Wrap the two ends around your left thumb and to the rear between the two loops.

5. Pass the left loop under the ends held by your thumb.

8. Fold the left loop to the right in front of the two ends.

Kikka-musubi

3. Fold the left loop to the right, passing back between the center and right loops.

6. Remove the left fingers gently and straighten out the four loops. Hold so that the ends stick up and to the left.

9. Fold the right bottom loop up between the two top loops.

1. Form three loops with a length of braided string.

4. Fold the center loop forward and down.

7. Fold the ends down over the thumb and the loops at left.

10. Fold the top loop in front of the others and through the loop held by the thumb. Pull the loops out gently to produce three large and four small loops.

2. Hold (1) in your left hand, bring the two ends upward and wrap over your left thumb and index finger, passing between the left and center loops.

5. Fold the right loop down, covering the center loop (4) and through the loop held by the thumb.

8. Fold the left bottom loop between the two loops at right.

Tying Styles of Mizuhiki and Kumihimo

Awabi-musubi **knot**: Since strands at left and right are entwined in this style, and do not easily loosen, the style is used for formal occasions, such as weddings or other occasions for celebration.

Musubikiri **knot**: Like Awabi musubi, this style of knot does not loosen easily, so it is used for occasions which are supposed to occur only once in one's lifetime. As the name, which means "cutting the tie" suggests, the ends are cut off after the knot is tied to stress that this is a once-in-a-lifetime occasion.

Morowana-musubi **knot**: This is also called *Cho* (butterfly) musubi. The knot must be the same color as the mizuhiki (or kumihimo) on the left side. This style is used for an occasion for celebration which we would like to repeat, such as the celebration of a birth or school matriculation. It may also be suitable for a gift for a sick person, because it loosens easily when the ends are pulled, symbolizing a release from illness.

Hana-musubi **knot**: This style takes the shape of such flowers as cherry blossoms (*sakuranohana-musubi*), apricot (*umenohana-musubi*), chrysanthemums (*kikka-musubi*), wisteria (*fuji-musubi*) or clover (*mitsuba-musubi*). This style is unbeatable when used in the appropriate color and season.

Katawana-musubi **knot (loop on one side)**: This is so called because one side of the knot is in the shape of a loop. It is mostly used for round or cylindrical shapes.

Musubi **(tying)**

In Japanese *musubi* means to connect, end or bind together as well as to pledge or promise. It is believed that when you tie things, a heavenly spirit will dwell within the knot to protect people. Thus the practice of knot-tying has become widely developed, especially for tools and playing games. Musubi have had several uses: 1. for counting, according to the number of tied knots, 2. as an ornament for clothing and 3. for symbolic purposes in Shinto rituals.

While tying in the West has developed mainly for practical applications, the Japanese musubi has developed as a form of decoration. Different styles of musubi have different purposes and are associated with various wishes and desires. Each has a unique name suited to its elegant form and symbolic meaning.

Washi

The first paper in Japan is said to have produced in ancient China, exported to the Korean Peninsula and brought to Japan by a Korean Buddhist priest, Doncho, during the age of Emperor Suiko (around 610 A.D.).

Washi (Japanese paper) is made by hand from the bark of *kozo* (paper mulberry), *mitsumata, ganpi* and other fibrous plants. The long fibers of these plants are entwined together during the paper-making process to create paper with the warm, soft texture unique to washi, yet with great strength and durability. The oldest known hand-made paper in Japan dates from 702; it is kept in the Shosoin, a repository for ancient artwork in the one-time Imperial capital of Nara. It is said that the silk and linen of the Tenpyo age (around 730–748 A.D.) look weathered, but the paper used for documents of that time is still as shiny and fresh-looking as it was when it was first used.

Today, you can purchase hand-made washi, machine-made washi or washi combining hand-crafting and machine processing, depending on how the paper will be used.

Machine-made paper is produced from needle-leaf trees such as fir or pine and wood pulp taken from broad-leaf trees such as Japanese beech or oak. Wood pulp has a short fiber, which is further foreshortened when cut into small pieces by machine. Machine-made paper may appear to be strong and firm, but is lacks the resilience of washi when folded and is thus not suitable for hana tsutsumi.

Kinds of washi

There is an enormous variety of washi. Although the paper producers or retailers may give similar types of paper different names to distinguish them, in general, each type of washi is named for its typical application, quality, basic materials, colors, production process, production locale, shape or other characteristics.

Danshi: This thick white paper with a wavy texture reminds Japanese of a cocoon, so it is also called *mayugami* (cocoon paper). It was originally made using the fiber of the spindle tree (*mayumi*). Danshi has long been known as a high-quality paper, used on ceremonial occasions or as fancy wrapping paper.

Hosho: This soft white paper was once used for official documents, or *hosho*, issued in the name of a shogun's subordinate to carry out the shogun's command. Gradually, the paper itself came to be called hosho. It is now considered one of the finest types of paper for woodblock printing.

Fuchibenishi: This white paper is square in shape, with all four sides rimmed in red. It is thinner than hosho and is frequently folded and used to place under Japanese pastries. It comes in three sizes — large, medium and small.

Unryushi: This washi comes in solid colors, and the paper is full of coarse fiber. The surface of the paper is slightly fluffy, giving a warm impression. Thin, beautifully colored unryushi is now on the market.

Kozoshi (**mulberry paper**): This paper was given its name because it is made from the bark of the kozo, or paper mulberry. It is also called *obarashi* or *mingeishi*. It comes in many solid colors and has a fluffy surface, giving a warm impression. It can be used in many ways, such as for the under sheet of Kifune tsutsumi.

Momigami: This thick paper features a wrinkled surface, as if it had been washed and wrung out. It comes in two types, either as a hand-made sheet or a lined sheet, and in a variety of sizes and colors.

Tengujo: With a thickness of 0.03 mm, this is perhaps the world's thinnest hand-made paper. It is soft, yet strong and difficult to tear. It can be dyed beautifully and can look very elegant.

Chiyogami: This paper, with its unique patterns, is said to have originated in Kyoto. There are basically three types: 1. paper used for poetry or hosho, featuring a pattern of flowering plants, 2. colored paper with an original design or a pattern of painted leaves and 3. paper featuring patterns of flowering trees or birds. The third type is said to have been introduced in Edo (present-day Tokyo); it is called Edo-chiyogami. Today chiyogami mainly refers to paper with patterns made by a stencil or a printing block. The effect is simple and hand-made.

Yuzenshi: It is not known when the name yuzenshi was given to this paper. Sourced in Kyoto, it is thought that the paper came to be called yuzenshi because of its classic patterns, like the famed *yuzen* kimono fabric from Kyoto. Depending on its quality, it can be used in various ways. Like kimono, the patterns in the paper determine whether it makes a casual or formal impression.

Kinsomegami: This golden paper comes in a wide variety of paper qualities and hues, including creased or frosted paper. A similar paper is available in silver.

Pattern-matching

Chiyogami and yuzenshi feature geometric patterns. For example, a representative pattern, *seikaiha*, resembles the scales of a fish. The patterns symbolize the waves of the sea, with an arc at the top. Yuzenshi patterns cover the paper and can go in all directions—vertically, right or left. Nevertheless, even yuzenshi patterns need to be aligned in hana tsutsumi, so that the pattern on the top sheet is not facing upside-down when the paper is folded. You should have in mind the finished appearance of the hana tsutsumi before cutting the paper.

Length and width of paper

Most varieties of washi are rectangular. "Place the rectangular sheet of paper lengthwise" usually means placing the shorter sides vertically and the longer sides horizontally. But with washi, as you can sometimes clearly see in the paper, the fiber runs parallel to the shorter side, which is referred to as the length. In order to avoid confusion, the direction of fiber flow is called the lengthwise grid (*tateme*) and the longer length of a rectangular shape is called the lengthwise position (*tateichi*).

Selecting and layering paper

In Kirara hana tsutsumi, we usually fold two sheets of paper or more, depending on the wrapping style. Because the underside of a sheet of yuzenshi or chiyogami is not attractive, it's important to select an under sheet of a matching color. First choose the top sheet, selecting an appropriate color and pattern for the hana tsutsumi style. Each style, such as Fuki tsutsumi, Shikibu tsutsumi or Yae tsutsumi, presents a certain image which must be matched by the paper. When using solid-colored paper, the paper quality is an important factor to consider.

Suitable paper to use as the under sheet would include elegant creased gold or gold-flecked washi. The paper should not be too thin or brightly colored, or the total balance and appearance may be badly affected.

Since Chigusa tsutsumi and Rikyu tsutsumi present a rather informal impression, paper with petite patterns such as butterflies or small flowers are suitable. Since Kifune tsutsumi is folded over at the top, patterns that are too small will not be appropriate. It is better to select bold patterns for something of this size.

The under sheet should also be of a suitable color. It is safer to select a color to match the colors of the top sheet. When the two sheets are placed back to back, their lengthwise grids should be aligned. The two sheets should match so well that they look as if they were glued together. But don't actually glue the paper, as glued sheets wrinkle when folded and look unattractive.

How to cut the paper

First prepare a base board of celluloid or other strong metal, a cutting knife, a ruler a tracing spatula. The base board should be strong enough to not be damaged by the knife blade and the ruler should be made of stainless steel or another metal and should be heavy and wide to keep the paper from shifting and ensure accurate cutting.

Place the board on a flat table top, match the grid patterns of the top and under sheets and mark with the tracing spatula. Holding the paper in place with the ruler, cut the sheets in a single motion. Because washi is entwined with strong vegetable fiber, it must be cut with full force.

How to fold the paper

Once the sheets of paper are ready, you can fold them. Make sure hands are clean, sit straight and face the paper. Since hana tsutsumi was an ancient samurai practice, it involves a certain etiquette of behavior to which you should adhere. Straighten your back, place your arms lightly to the sides of your body and fold the sheets of paper as if from the elbows.

As you fold, roughly measure the dimensions with your eyes but also concentrate on the overall shape. Do not correct small discrepancies; just fold the paper in one motion. If the shape is distorted, discard the sheets and use new sheets of paper. Never refold them as each fold should be done only once.

Some people feel that the finished shape is more important than the folding procedure, while others move the sheets about while folding them. But such an approach should be avoided, because there is a marked difference between the hana tsutsumi thus produced and those folded the correct way, even though the finished shapes may look similar. When you have an image in mind of the finished appearance of the hana tsutsumi while folding the sheets and understand where the section you are currently folding fits in, your work will be easier and the finished product more beautiful.

In Japan we say we fold not only sheets of paper but also our own mind. In fact, there is a Japanese phrase, *orimetadashii* (properly folded), which means "well-mannered," reflecting the importance that the Japanese attach to folding things properly in daily life. For example, paper is never cut with scissors, as it's less precise. The basic premise of hana tsutsumi is that no matter how complicated a shape is, it always turns back into a sheet of paper when it is unfolded.

Bibliography

Hoketsu Zesetsu, Ise, Teijo, Kokusho Kankokai, 1987
Ogasawararyu Hoketsu no Shirube, Kagetsu-an, Kakuyu, Daibunkan, 1941
Origami to Mizuhiki, Yamaguchi, Kazuyoshi, Murata Shoeikan, 1943
Reiho no Kenkyu, Sakurai, Mamoru, Zoshindo, 1943
Ogasawararyu Shitsukekata Hyakkajo, Eijudo, 1843
Joshi Kyoka Hoketsu no Shiori, Okura Shoten, 1900
Kojitsu Sosho-Teijo Zakki, Ise, Teijo, 1843
Himo, Domyo, Shinbe, Gakuseisha, 1963
Ikebana Bijutsu Zenshu, Shueisha, 1963
Tsutsumi, Nukata, Iwao, Hosei Daigaku Shuppankyoku, 1985
Orikata no Reiho, Yamane, Akihiro, Yamato Shobo, 1978
Orikata Tsutsumu Kokoro, Araki, Makio, Bunka Shuppankyoku, 1978
Musubikata Zensho, Takeuchi, Motoyo, Ikeda Shoten, 1988
Edo no Chiyogami Isetatsu Sandai, Hirose, Tatsugoro, Tokuma Shoten, 1977
Iro no Saijiki, Asahi Shimbun, 1986
Heian no Bisho Kasane no Irome, Nagasaki, Seiki,
Kyoto Shoin, 1988

Acknowledgements

I would like to thank the following people and
organizations for permission to publish
my first book in English.
Photographs by
Akira Kumagai: 19, 28, 30, 61, 75,
Tetsuyata Shimazaki: Cover, 11–13, 23–25, 29, 38–39,
44–49, 51 top, 54–55, 57, 62–63;
Jiro Suzuki: 88–111,
Michio Tanaka: 14–18, 20–22, 26–27, 31–37, 40, 41 top,
42–43, 50, 51 bottom, 52–53, 56, 64–73, 76–85.
The Mainichi Shimbun,
Fujin Gaho-sha,
Yoko Seki,
Michiko Kinoshita.

School
KIRARAKAI
Yubi Mansion
2-6-36, Taishido, Setagaya-ku,
Tokyo, 154 Japan
Tel: Tokyo (03)3419-4193